MW00777209

STORIES OF *REIMAGINING* THE *FOUND TEXTS* STREET

DAVID LAZAR

University of Nebraska Press Lincoln

Figure 29 (p. 53) courtesy Jane Burton.
All other photos by the author.

The University of Nebraska Press is part of a land-
grant institution with campuses and programs on the
past, present, and future homelands of the Pawnee,
Ponca, Otoe-Missouria, Omaha, Dakota, Lakota, Kaw,
Cheyenne, and Arapaho Peoples, as well as those of the
relocated Ho-Chunk, Sac and Fox, and Iowa Peoples.

Library of Congress Cataloging-in-Publication Data
Names: Lazar, David, 1957– author, photographer.
Title: Stories of the street: reimagining
found texts / David Lazar.
Description: Lincoln: University
of Nebraska Press, [2024]
Identifiers: LCCN 2024018826
ISBN 9781496238498 (paperback)
ISBN 9781496241467 (epub)
ISBN 9781496241474 (pdf)
Subjects: LCSH: Street literature. | Printed
ephemera—Pictorial works. | Street photography. |
Photography, Artistic. | BISAC: PHOTOGRAPHY /
Subjects & Themes / Street Photography |
PHOTOGRAPHY / Photoessays & Documentaries
Classification: LCC Z1029.3 .L39 2024 |
DDC 818/.6—dc23/eng/20240705
LC record available at https://lccn.loc.gov/2024018826

Designed and set in Minion Pro by L. Welch.

In memory of Marty McGovern
found and lost

The cities they are broke in half
and the middle men are gone.

—**LEONARD COHEN,** "Stories of the Street"

[The flaneur] would be happy to trade all his
knowledge of artists' quarters, birthplaces
and princely palaces for the scent of a single
weathered threshold or the touch of a single
tile—that which any old dog carries away.

—**WALTER BENJAMIN,** *The Arcades Project*

So long as I remain alive and well I shall
continue to feel strongly about prose
style, to love the surface of the earth,
and to take a pleasure in solid objects
and scraps of useless information.

—**GEORGE ORWELL,** "Why I Write"

Contents

To the Reader xi

The Worry Anchor 1

Ghost List 3

(Boy) (Girl) 5

A Knife on a Fault Line 7

Air Quote 9

Apocryphal 10

Basement 13

Big Dog 15

But Seriously 17

Carly, Sorry 19

Chicago Hotel 21

Closing Time 23

Distaff 25

Face Down 27

A Supposed Examination
of Entanglements 29

Two Times Six 31

Action Petition 33

Fireball 35

Forty-Eight Bucks 37

Have a Light, Janine? 39

Hermeneutics 41

Interval 43

It's Late 45

Forgotten in Death 47

Troy's Prophecy 49

Down by the Lake 51

Jane Burton 53

Why Do Some Objects
Favor Us with Their Loss? 55

Je Suis V——, Napoleon 65

Jewish Museum 67

Wize Guise 69

Light Man 71

Love and Loss 73

Thrall 75

Love's Lost Lake 77

Thus the Photograph 79

Malo Grablje 81

I Am Writing This in Chicago 83

On Wednesday, March 8th,
at Six O'Clock p.m. 86

Mirror, Mirror 89

New World Order 91

Reading by Nina 93

Read, Goddess 95

Robin? 97

Scripting 99

Sequence 100

Sinatra Matters 103

What's My Color IQ? 105

Succession 107

Temperature Could Be Rain 109

The Tigers, Baby 111

Telling a Story 113

Locations of Found Texts 115

Acknowledgments 119

To the Reader

For the last ten years or so, I've noticed that there are texts everywhere; the ground is full of messages. Some are written by hand, some printed; there are scraps of paper and schoolbooks, advertisements and quickly scribbled telephone numbers, lists and equations, postcards and abstruse lines on lined or unlined pages, untranslatable. At some point I became fascinated with the world of ephemeral messages at my feet and began stopping to read and then photograph them in place, not sure at all what, if anything I might do with them, or what they might mean, but sure of my fascination, of my sense that there was this subworld, this arcane lost world on the streets, of messages that had escaped their bottles, their owners or carriers, perhaps dropping listlessly from pockets like open mouths, crumbs on the ground I might follow. They were lying listlessly along with the leaves, in the gutters as the rain started, or the fading like dissipation of time spent walking aimlessly on the street, threatening their very existence with illegibility, or partially readable, like a textual dementia that challenges you to make sense of what is lost.

This book is in thrall to Walter Benjamin: the lyrical synecdoche of the city; the city as casual historical oracle. Fragments of what George Orwell calls "scraps of useless information" that might be revelatory given time.

Once again, via Benjamin: the city is a two-way street. In "One-Way Street" Benjamin writes,

> What is "solved?" Do not all the questions of our lives, as we live,
> remain behind us like foliage obstructing our view? To uproot
> this foliage, even to thin it out, does not occur to us. We stride
> on, leave it behind, and from a distance it is indeed open to view,
> but indistinct, shadowy, and all the more enigmatically entan-

gled. Commentary and translation stand in the same relation to the text as style and mimesis to nature: the same phenomenon considered from different aspects. On the tree of the sacred text both are only the eternally rustling leaves; on that of the profane, the seasonally falling fruits. (*Reflections: Essays, Aphorisms, Auto-biographical Writing* [New York : Schocken Books, 1978], 67–68)

The "foliage" I found isn't meant to be solved. Nor do I wish to turn the indistinct into an enigma. Instead, what Benjamin calls "commentary and translation" are my way of confronting, imaginatively, and one can only hope sympathetically, these fallen fruits and giving them a much more profane than sacred second life, and "ambiguity replaces authenticity" (*Reflections*, 75).

I've noted the approximate date and place where some of these texts were found, not because they especially shed light on the contents themselves but as a kind of footnote, a nod to the hybrid nature of what I've written, the plainest denotation of which might be called "responses," a charming generic abyss that prose occupies when formal affiliations are oppressive, inappropriate, or just unavailable. Some might call these responses *hybrids*, a term of some marginal use that has already become somewhat mossy. I'd probably prefer *circus acts*, maybe just because it sounds so *recherché*. No animals, however, have been either involved or ill-used.

I have written some responses to images, as well as texts; they are alternate texts. Those of you who wander cities understand the lure of the stray image, the absurd, ironic, surreal, uncanny tableau that appears on the street of crocodiles. I have included a few of these as interludes, entr'actes between the messages lacking bottles that have caught my eye as I walked and walked, sullenly, moodily, occasionally however with a strangely jaunty amusement, down streets near and far, in cities—I've never met one that wasn't interesting.

Gazing at surfaces, the flaneur may as well call his project, "On the Virtues of Looking Down."

Or: the world is a bottle with no message inside. We write the messages ourselves and once in a blue moon the sea concedes.

STORIES
OF
THE
STREET

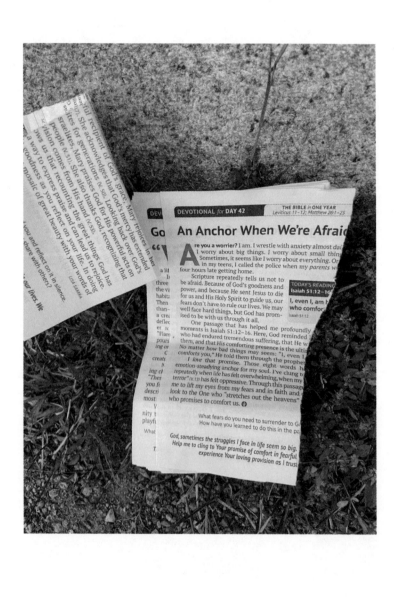

THE WORRY ANCHOR

As a worrier, I wrestle with worry the way Jacob wrestled with the angel, or God, or his shadow self, or . . . whatever the hell it was.

Worry is also my familiar, and I call it Harry, so no matter how bad things may seem, I know I have a handle on the brown and gold, the ruby-throated duties that push me hither and yon and lord over their transcendently ordinary necessity, which I am sometimes sure I am unable to fulfill.

To fulfill is different than to feel full. My struggles are about the anxious ducking away from moving shadows, the ticky avoidance of the fly-by-night worries I lack the strength to shoo into the background. Are birds and bats the same thing in the dark? Worry is the thing with wings.

I'm not anointed, not appointed, but disjointed may be just right, like the anxiety before which porridge is just right. Who, I ask you, would suggest an anchor for a soul so leaden, so earthbound? If God were an anchor, I'd be in trouble, Harry, because I need solace to defy gravity. This is why I have torn the devotional, the devotional of the dam, thinking that pages might be like prayers; ripped from us we hope they find another source, perhaps their all-knowing reader, whether they're downriver or upstream.

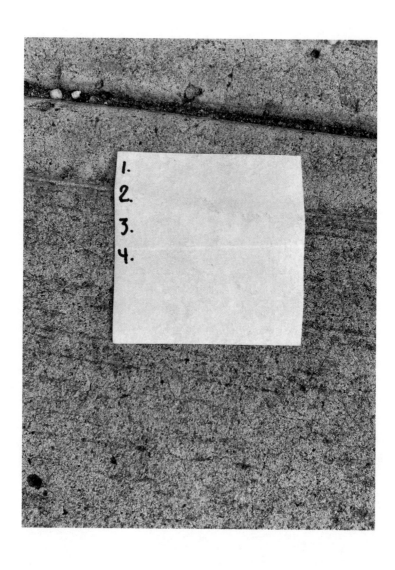

GHOST LIST

Here lies a list that was written on water, or invisible ink. The lost list always begs the question of whether it was discarded because fulfilled, or thrown to the wind so it could *not* be, an indignant rejection of listing's autocratic demands. True, scattered notes might also be lost, textual children who dropped the hand of their parent. But who picks them up—what sorry soul, eyes to the ground, rudderless, listless—only to try and create direction, meaning, from the effluvium at their feet? The search for messages, the stories of the street, suggests a certain aimlessness, or a purposeful losing of oneself, that is the mark of the flaneur.

The open list is a grand, central list, a meta-list, Ur-list, the essence of the listing impulse: enumeration. An even number in a handsome script is a stay against profusion. But if writing a list soothes the momentary fear of aphasia, the impulse itself exhausts the enterprise. Things to do: nothing. Needed to buy: nothing. But I feel one must have some sequential sense of what is necessary. Otherwise, what would or could you do, wandering out in a brisk spring matin, but look for a list, a search that you couldn't possibly itemize.

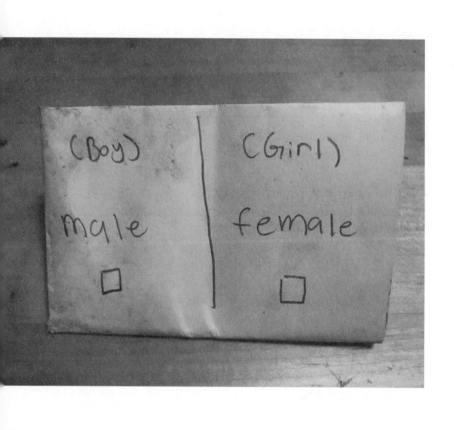

(BOY) (GIRL)

Was this a child's game, or an attempt to reduce the world to a binary? Was it given to someone as a guessing game? What do you think? What am I?

Was it offered as a choice of reincarnation? Boy is to male as girl is to female as song is to opera as my father disappearing around the corner was to my mother. What can we see from the cliffs? It's hard to tell someone's gender from behind—the back of the page is blank. But what, after all, is the back, since it's folded four times?

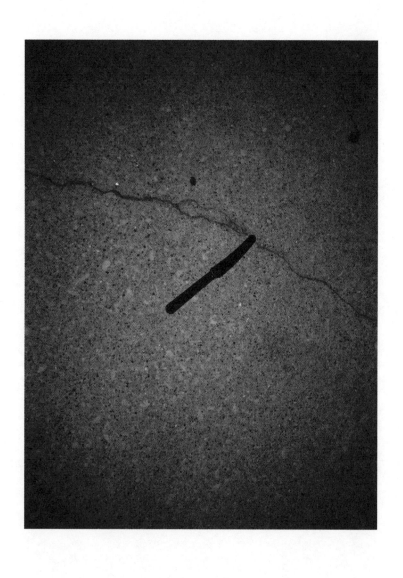

A KNIFE ON A FAULT LINE

A knife on a fault line, piece of cake. Why does God use plastic, still? I would like a Ginsu deity. But a less apparently powerful object is so attractive, so erotic. Sharp, but bends.

I want to be concrete cut by plastic, and point pure north to my split sides.

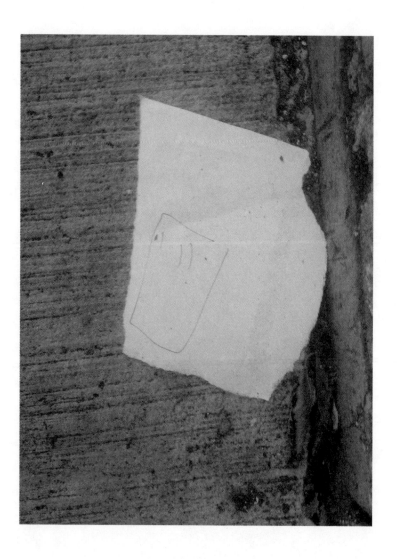

AIR QUOTE

Someone tried to contain an air quote that somehow escaped.
Or in frustration at its escapability, the very idea was torn asun-
der. I empathize with the impulse, having suffered, as perhaps
have you, from dozens, dare I say of countless conversations in
which hands intercede, meddle really, in a perfectly comprehen-
sible convo, sometimes so forcefully as to cause me to fall back,
reel almost, from the vulgar hooking of fingers meant to signify
quotation marks around what was just said. More than that, the
fingers suggest, they even denote the dubiousness of the invisible
word hanging in the air. Fool, I've thought, you're only under-
mining the lexicon of air and undermining what could have
been really memorable chitchat.

This scrap of an attempt to visually display how the odious air
quote might be nixed, nayed, neined, and altogether contained
must have gone what I call "fraughty" because the "close-
earedness" of the unpercipient auditor, the unheeding, hedging
stooge, the "quote-abuser." Did she or he "crackle the rip," as we
say in the torn paper trade, "do the deed," "violent the page,"
or was it my friend in this project of verbal empathy who grew
frustrated, my imaginary dialogist so dear to my heart. Oh inter-
locutor supreme, Harvey-esque bunnytalker of my mind, now
suddenly so endearing in your earned annoyance, I could almost
let you flay an apostrophe near my lips.

APOCRYPHAL

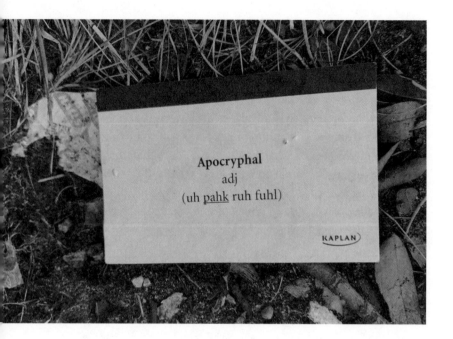

Ruefully, my mother done told me that I could read in the womb. She'd shake her head and say, "Boy, I don't know what you found so interesting so young, or how in the world they got you the Sunday papers, but you were at it with those eyes before they could slap a cry through your lips." When I was knee-high to a Britannica, one day, because of everything I read, I told a teacher how to say the longest word they'd ever heard in that county. I'd read it in a book, you see, and therefore it must be so.

Taumatawhakatangihangakoauauotamateaturipukakapikimaungahoronukupokaiwhenuakitanatahu

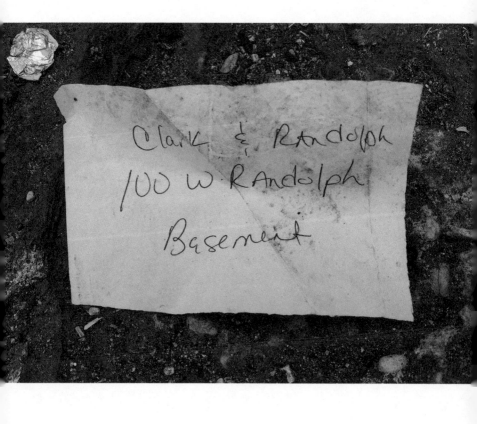

BASEMENT

Give them a piece of tin at the door and they'll let you in.
Forget "Swordfish." It doesn't take much to access a basement.
A deep place, the depths, how much talent is there in descent?
A huff of a morpheme, and you're in the worst of all possible
places: debasement. To a tin ear it sounds like you're trapped,
but debasement is a kind of wretched freedom, and all it takes
is a tin ear. Clark and Randolph my ass, two guys who have too
many degrees, too many degrees of basement. My ass is debase-
men. I gave them a piece at the door. I wished I could trade my
morpheme for morphine. Delicious, delightful, delovely. I really
need a seller. Cellar. What's damp and deep and black all over?
Basement, baby.

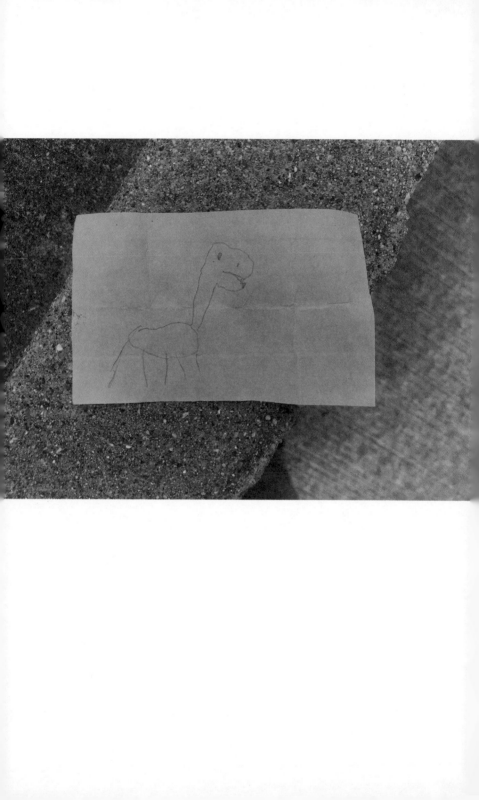

BIG DOG

—Big dog?

—Uh-uh.

—Squirrel on a branch?

—No, no.

—Maybe racoon? They like smelly garbage, wear black masks like Uncle Frank.

—No blackgun. Not.

—Will you draw a picture of what you saw by the window? Then we can talk about it.

—Here was. Big. Like eat.

—Oh, honey, it looks like a big old dinosaur. Like from the books we read. Is that what you're trying to say?

BUT SERIOUSLY

But seriously, Thanks Thomas Hardy.
But seriously, Thanks Marie Curie.
But seriously, Thanks Satchel Paige.
But Seriously, Thanks Phil Ochs.
But Seriously, Thanks Jean Ritchie.
But Seriously, Thanks Ramsey Clark.
But Seriously, Thanks Ahmad Jamal.
But Seriously, Thanks Elizabeth Smart—by Grand Central
 Station I sat down and wept too.
But Seriously, Thanks Dorothy Dinnerstein.
But Seriously, Thanks Mom! Seriously!

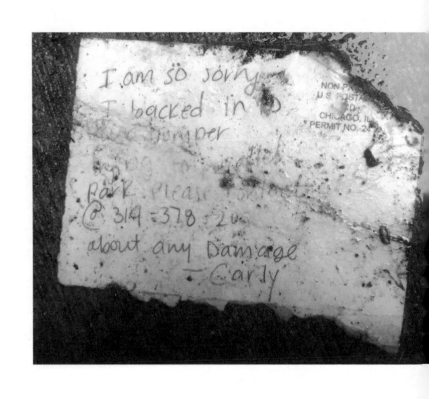

CARLY, SORRY

"I am so sorry
I backed in to
Your bumper
Trying to parallel
Park please contact
319-378-20**
About any damage."

That was the first version, which Carly gave me as a souvenir.
Two years later, she had worked it into:

You're so vain
I bet you think your car
Is about you
You're so vain
I bet you think your car
Is about you
Don't you, don't you
Know how to parallel park?

I don't speak to Carly very much anymore. The note has been
ill-used by dirt, by time, by my car.

She and I had a talk once about the things we accidentally
damage: cars, garbage cans, plates, children. We talked about
leaving notes on the things we broke—the tattered note on the
sideswiped car, the hurried ripped-out notebook page left for
the Airbnb owner whose shower head was dented in an acrobat-
ically freaky fluke of morning hijinks, the diary page pinned on
the teenager who you traumatized and could no longer speak to.

At some point, all you can do is say, i.e., the teen, "Sorry for the things I've done, let me know how much it will cost."

Carly, who had a tendency to repeat herself, left me a note once.

As I recall:

> You're so vain
> I bet you think your teen is about you
> You're so vain
> I bet you think your teen is about you
> Don't you, don't you?

CHICAGO HOTEL

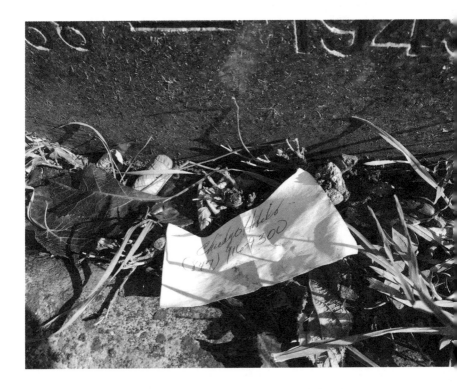

I hit the horn and made nice like Santa Claus—it isn't hard to get a rat to lead you to the cheese. Chicago Hotel, just a side street joint for the down-and-out, three bucks a night, no questions asked. Not even, "What's your ontological status?" Yeah, the desk mug told me, she's there, not at Covenant House or Mrs. Jennings Rooms, or even the flophouse of flophouses, just called Hotel, down near Diversey and Cicero. I'd worn the leather out trying to trade an answer for a loaded question in gabardine.

She was the knife I cut myself with. The gaudy hootch that burned my throat. She was the grifter of my soul. And no matter how hot it was, I knew she'd be my Chicago overcoat.

Third floor, number three the mug tells me, like it's my lucky day on the ash heap. I head up, but why is it called a flight of stairs even when you're heading down? I always liked the cheap hotels because I always thought that's just where I'd end up, the way you give a stupid grin to some yap with a sap who was just waiting around the corner to give you a ticket to dreamland.

I listened at her door, almost as quiet as I would have thought.

That was in 1942. Some memories need a decent burial.

CLOSING TIME

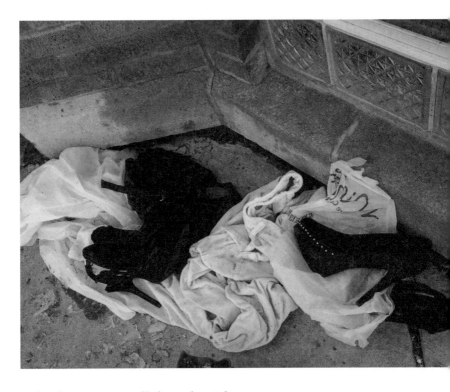

I no longer care at all about the night.
Some people say I'm blasé, but they don't know.
Bright light, no light, no difference, right?

When the bars close the voices are all contrite.
Everyone sounding like a loud sorry show
But I no longer care at all about the night.

Once I met a boy, good skin and so polite.
Kissing me in corners was his sweet m.o.
Bright light, no light, no difference, right?

But even with the innocent sometimes you fight,
You try to make them love you by saying you'll go.
I no longer care at all about the night.

Love's a glass on the bar's edge, right?
You think it's all about the balance, but no.
It's bright light, or no light, the difference, right?

Mister you're looking at me as though I'm tight.
And when that happens it's time for me to go.

DISTAFF

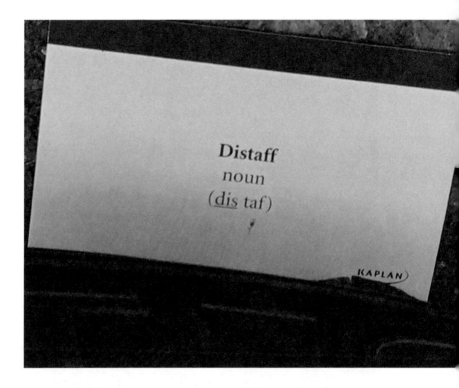

Adj., from the Melancholian, Di-staff, archaic, a group of women working for a princess. Other etymologies, dis-taf, ancient Norwegian, the most surly or rough woman in a subgroup, the woman who would wound men for no reason; an honorific.

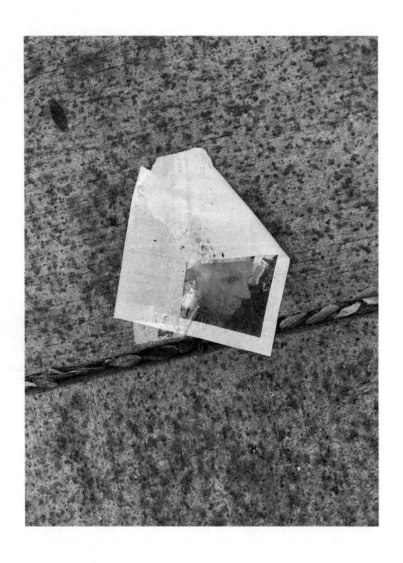

FACE DOWN

Studies have shown that when an image of a visage falls, it is almost never face down, unlike their unfortunate avatars. A face in the street is technically a stray, akin to a photographic orphan. These are never happy faces. They usually look to the side to avoid startling or angering passersby who might happen to glance down.

When I have fallen face down, I usually linger there a while. I appreciate the strangeness of lost bearings, the horizontal humiliation of existing on the visual plane of a rabbit. If I am injured, I like to feel the waves of pain current through my knees or arms, my temple. It's soothing to be underfoot.

In the photograph, the man's head is partially covered by a fold, like a bandage or a white party hat. I relieved the pain of solitude by stepping on his face.

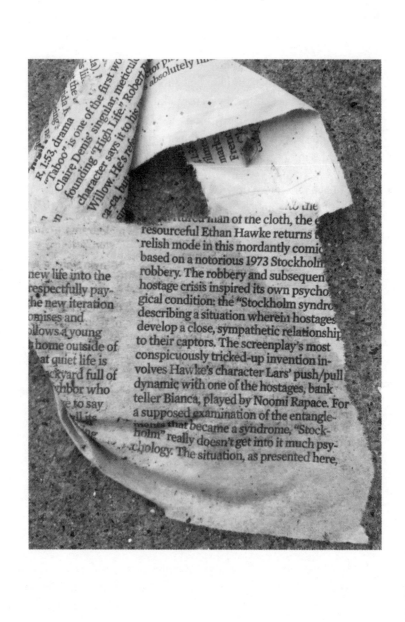

R 1:53, drama
"Taboo" is one of the first wo
Claire Denis' singular, meticu
founding "High Life." Robert
character says it to his
Willow. He's ref

new life into the
respectfully pay-
the new iteration
omises and
ollows a young
home outside of
at quiet life is
ckyard full of
hbor who
e to say

absolutely m

man of the cloth, the
resourceful Ethan Hawke returns
relish mode in this mordantly comic
based on a notorious 1973 Stockholm
robbery. The robbery and subsequen
hostage crisis inspired its own psycho-
gical condition: the "Stockholm syndro
describing a situation wherein hostages
develop a close, sympathetic relationship
to their captors. The screenplay's most
conspicuously tricked-up invention in-
volves Hawke's character Lars' push/pull
dynamic with one of the hostages, bank
teller Bianca, played by Noomi Rapace. For
a supposed examination of the entangle-
ments that became a syndrome, "Stock-
holm" really doesn't get into it much psy-
chology. The situation, as presented here,

A SUPPOSED EXAMINATION
OF ENTANGLEMENTS

I am Ethan Hawke and not Ethan Hawke, in the way that the man in the castle keep is both a prisoner and the prison—is moved by his guard and can make the guard move, the execution go forth, by merely staying alive. Yet I can do nothing about the bird tormenting the window. I allow the world, so desiccated and paradoxical, to exist, because of my warped will to live. This is the power of my weakness, which I love. Understanding this was your gift to me, sir. Can I go for a walk before it gets too late? The situation, as presented here, will not much change.

In the same way, Ethan Hawke, in his trailer, struggles to shuck the character he is made to play by his puppet-master director. The show goes on. "Turn toward the lights just a little," I hear him being told, "and a little more inflection on 'nostrum,' the word 'nostrum.'" Ethan nods and thinks this wise advice as someone yells "Action!" or "Help" or maybe it was "Non serviam." Cameras roll as boats struggle in the high waves. Who doesn't suffer from Stockholm Syndrome, especially a method actor who falls for his own empathies?

Yes, in the castle keep there is a reason for bars, reason for the prickly hay (Ethan, I'm sure, knows this) and who could be safer than the person who yields, given over to a shadow of a shadow who always knows what's best. The Shadow knows what's best. And who knows better than a hostage to fortune that the situation, as presented here. . . .

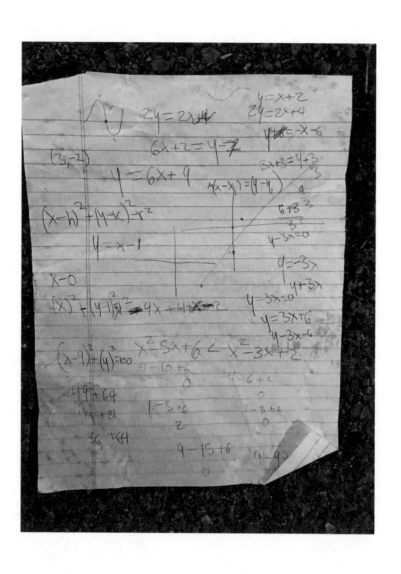

$y = x + 2$

$2y = 2x + 4$ $2y = 2x + 4$

$6x + 2 = y - 7$ $y + 6 = -x - 6$

$(3, -2)$

$y = 6x + 9$ $3x + 3 = 4 + 3$

$m(x - x_1) = (y - y_1)$ a

$(x - h)^2 + (y - x)^2 = r^2$ $\dfrac{6 + 3}{3}$

$y = x - 1$ $y - 3x = 0$

$x - 0$ $y = -3x$

$y + 3x$

$(x)^2 + (y - 1)^2 = 4x + 4 = 2$ $y - 3x = 0$

$y = 3x + 6$

$y - 3x = 6$

$(x - 9)^2 + (y)^2 = 100$ $x^2 - 5x + 6 < x^2 - 3x + 2$

$9 - 10 + 6$ $4 - 6 + 2$

$9^2 + 64$ 0 0

$y^2 + 81$ $1 - 5 + 6$ $1 - 3 + 2$

$36 + 64$ 2 0

$9 - 15 + 6$ $9 - 9$

0

TWO TIMES SIX

There are secrets to geometry that even I don't know, I (not 1) who have spent his (their . . . thems . . . but denoting one) whole life devoted to the overlap of the simple and complex. Sometimes the only numbers on a continuum are contiguous.

Plus, and, added to, in addition . . . the days all counted. And when she left, a subtraction put me at absolute zero. The only thing that pulled me through was twelve hundred and nineteen, so muted and yet so liberated in its vowels, numbers, and letters knowing what they were doing together . . . more than, I was convinced, any other numbers.

Our delusions are beautiful when they save us from facts that would calcify necessary truths.

I once was stopped jumping off the Ten Cliffs by the number twelve. *Twelve, shelves,* the domestic cliffs of the homeland too homely to claim the sad clichés of negativity.

Now is a quality that won't stay put. Time, clock time, ticks on my wrist like the afterthought of the big bang of a book falling to the floor. The dust flies everywhere. That happened once.

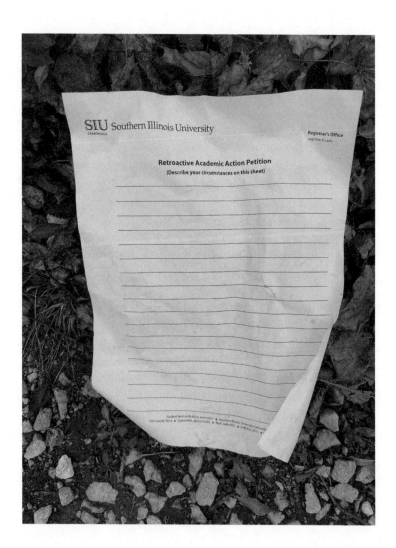

ACTION PETITION

I hereby would like to retro in the matter at hand—scratch.
No. Retroactively, I petition the academic matters that be for
exclusion or inclusion, come what may, in full, or at least partial
restitution of status, tenure, full acknowledgment of service of
both inner and outer, including teaching, counseling, publica-
tions, including but not limited to this particular paragraph,
interesting and extensive remarks made in passing that may
have been germane to the life of the university, amusing forays
into things once considered *recherché* like research, vaudeville,
or burlesque, but which the petitioner still finds fundamental
to any reasonable culture, and can be found in music or spoken
word, scat poetry, unnamable performances, and the like. This
petition asks, too, for some sense of leaked soul in the ground,
contaminating the water supply, which may have been caused,
intentionally or not, by academic obliqueness, bureaucratization,
or general hard-heartedness. Damages, yes, I'm talking damages.
The application does not require any admission of Dickensian
misadventure or capitalistic cold-bloodedness. It does not admit
to false innocence or stubborn self-righteousness. It just wants
to not argue anymore and be left alone. Is that too much to ask
for? Come on, now, is it?

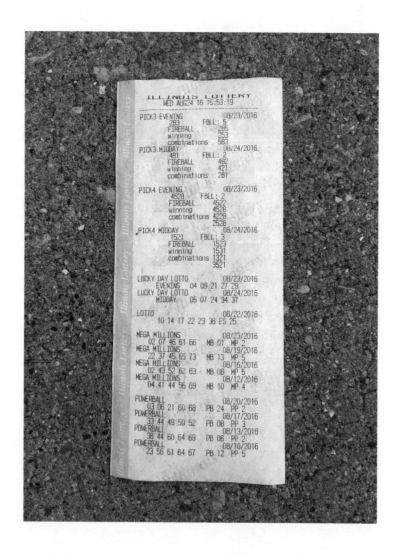

ILLINOIS LOTTERY
WED AUG24 16 15:53:19
--
PICK3 EVENING 08/23/2016
 283 FBLL: 5
 FIREBALL 285
 winning 253
 combinations 583
PICK3 MIDDAY 08/24/2016
 481 FBLL: 2
 FIREBALL 482
 winning 421
 combinations 281

PICK4 EVENING 08/23/2016
 4528 FBLL: 2
 FIREBALL 4522
 winning 4528
 combinations 4228
 2528
PICK4 MIDDAY 08/24/2016
 1521 FBLL: 3
 FIREBALL 1523
 winning 1531
 combinations 1321
 3521

LUCKY DAY LOTTO 08/23/2016
 EVENING 04 09 21 27 29
LUCKY DAY LOTTO 08/24/2016
 MIDDAY 05 07 24 34 37

LOTTO 08/22/2016
 10 14 17 22 23 36 ES 25

MEGA MILLIONS 08/23/2016
 02 07 46 61 66 MB 01 MP 2
MEGA MILLIONS 08/19/2016
 22 37 45 65 73 MB 13 MP 5
MEGA MILLIONS 08/16/2016
 02 43 52 62 63 MB 06 MP 5
MEGA MILLIONS 08/12/2016
 04 41 44 56 69 MB 10 MP 4

POWERBALL 08/20/2016
 03 06 21 60 68 PB 24 PP 2
POWERBALL 08/17/2016
 33 44 49 50 52 PB 08 PP 3
POWERBALL 08/13/2016
 38 44 60 64 69 PB 06 PP 2
POWERBALL 08/10/2016
 23 56 61 64 67 PB 12 PP 5

FIREBALL

When I buy the Fireball lotto ticket, as measure of good luck, I sing to myself the song from a children's program I loved when I was one of the children:

> My heart will be a fireball
> A fireball
> And you will be my Venus
> Of the stars

When you're dealing with matters with luck, every detail counts. This is why, according to statistics, fetishists win the lottery five times as often as "normal" people.

Those with OCD, according to unofficial surveys, account for up to 75 percent of winners.

So you can understand my attentiveness to a sentimental association. The fireball was a spaceship and the characters in the program were marionettes who seemed all too real to me. I found their jerky movements natural as they went about their space-age business in the future. Winning the fireball lottery would allow me to move fluidly in the future, not as a puppet, which I sometimes feel like, controlled by the whims of others, pulled by strings I'm very aware of except when I'm not, but liberated into my own dance in the world. I would be like a remote-controlled toy whose remote control was broken.

So I place my bet on fireball. To be free, I think, would be to have your heart set off like a rocket. And once that was done, wouldn't my very own Venus of the stars be just the next step? I'm betting on it.

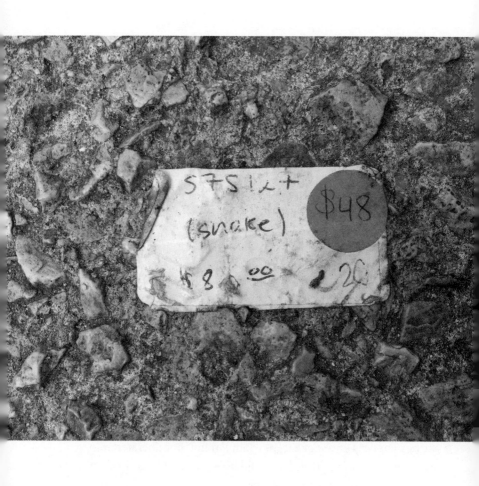

FORTY-EIGHT BUCKS

Maybe you think fifty sawbucks is a lot to pay for a common viper, but the kid wanted a milk snake for his fifteenth jubilee, and I was always Mr. Softy where she was concerned. Plus, I always liked the sound of, "Red on yellow will kill a fellow, but red on black is a friend of Jack"—I had an uncle Jack who used to take me walking down the docks after he was demobbed, and never once of all the big heads I knew then asked me why it was I walked so low to the ground, so I figured that was one for the kid, and one for me, and all for the price of forty-eight smackers. It made me start to think of what we would do when the thing got out. I'd look all around the house, the neighborhood even, calling out to the snake, whose name was Snake, like I was some kind of lunatic. My kid, you should know, was beside herself when it actually happened—*beside herself*, what do you think of that, like we shed ourselves when things get too rough—and I had to calm her down with thoughts of snake dreams and the like. "Don't you worry, darling, she'll come slithering back." Well, now, she and I, we're seeing snakes everywhere: under the boardwalk, in the movie theater, in Mrs. McGaffrey's hat. I said, "Don't you fret, baby, I see another snake in your future." Like a lot of things, just forty-eight bucks away.

BEN

Yes, I dream.

JANINE

What do you dream about?

BEN

What do you want from me?

JANINE

I didn't mean no harm by comin' in
here. Like I say, just wanted to say,
"sorry," and stuff. (beat) And. . .

BEN

And?

JANINE

And be close to you. . .

She is embarrassed.

BEN

Aren't you on your honeymoon?

JANINE

I don't love him. Not now. I don't
know if I ever did.

BEN

Then why did you marry him? (beat)
No, it's none of my business.

They are close.

BEN

I dream that I'm in a police station,
and I'm accused of a crime, and all I
have to do is write the address of the
guy who framed me, but I can't remember
the alphabet, or what say of the
letters look like. I think I'm spelling
words, but when I look at it, it looks
like gibberish. Like Arabic, or hieroglyphics.
I have that one a lot, lately. (beat) Not too subtle,
huh?

JANINE

HAVE A LIGHT, JANINE?

All the world's a screenplay, and we are merely deconstructing it, or just listening to the leaden lines from the couple sitting next to us at the coffee shop, half borrowed from a lazy dream. Someone always has to think something, try to expose some tired element of character. Someone always has to say something. After Ionesco, all characters should have been screenwriters, born without access to language. After Beckett, all characters should have stopped waiting. After Pinter, it should have been mandatory that characters who don't cause each other exquisite pain, in language that cuts one's sensibility like butter, should die in the first act. According to Chekhov, if a character dies in the first act he will be dead in the third act. The first action of a character who can't say something fascinating should be self-immolation. The screen and stage should be full of self-immolating characters, burning for their clichés.

On the next page, Ben and Janine chase each other around with lighters, trying to set each other aflame. Unlike the monks who torched themselves in protest, Quang D'urc and others, Buddhist self-sacrifice for the occupation of their country, along with their American followers: Alice Herz, an eighty-two-year-old peace activist, Norman Morrison, a thirty-one-year-old Quaker who doused himself with gasoline and set himself on fire under Robert McNamara's window . . . I wonder if seeing a body aflame, the death of a human spirit, so close to home, caused him to wonder about the character of character, the nature of our and significance of gestures.

Ben: Wow, that's kind of depressing, if you really think about it.

Janine: Do you think love can really last?

Ben: (taking out a cigarette) Have a light, Janine?

HERMENEUTICS

The morphological message is a sand trap, a dance, a seduction, a body with blank face, the last twenty years. How they—if "they" is quite right—knew to leave it there, and yet not *there* for me, on March 7, 2001, is too inscrutable to even imagine. Even rabbits like me don't dive down certain rabbit holes. But it was waiting where I'd find it, the arranged marriage of coincidences.

Please understand, every arrangement has a sense, every mad sequence was sequenced for a reason. *Every picture might be worth a thousand words, but which thousand words?*

These were my thoughts, years after I found it: *Seabirds, flocking through galaxies, cannot outlive their own inner demons, except through some pretty exigency that involves the movement of the group.* It was, as I recall, a bad day. Yolanda devastated me by insisting on what we came to call "the sullen arch of lower Italy."

My next attempt, twenty years later, when all the little fires sent burning pieces of paper over Dover like the celebration of an historical rebuke, was more pithy: *Pointillism is no way to live, but that doesn't mean we have to leave the house every Sunday.*

I was accused of indeterminacy, then highly frowned upon.

Finally, with the nights all rickety and all the dentists continually dancing, I buckled down and came up with what is now considered the definitive interpretation. I leave you with it, and add, for those who can remember consumption, this caveat—no one is what they remember eating:

The shape of underwater shoes does not mesh with the imperative to sink, but go there. And then leave.

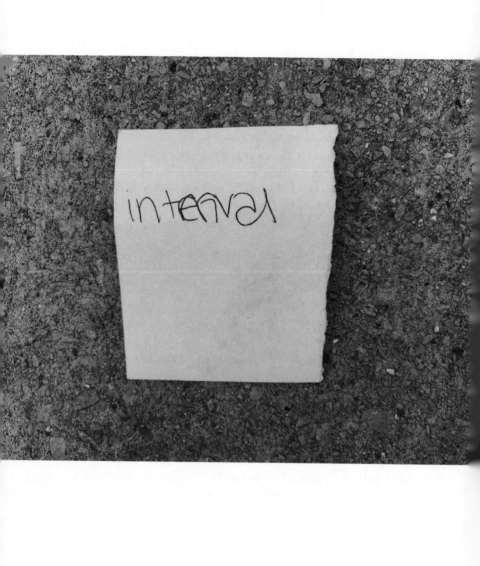

INTERVAL

Someone has discovered that intervals are internal, and hard to spell, and then left it at that. It isn't difficult to lose an interval, especially the internal interval in that space below the femur where you can drop inside yourself into the blue darkness and float in your own fluid selfness. This should be called *forsooth*, a withdrawal into the body, the self-suction or self-seduction.

Once there, I think about the corner luncheonette from my childhood, split myself in two and serve up a memory sandwich and a chocolate milkshake. The swivel counter seat spins me down into what sounds like murmurs and distant subway trains.

But someone has lost their *internal interval*, or perhaps lost in themselves marked their descent before they disappeared. They might be right in front of me, no longer reachable, as I am no longer reachable to so many others.

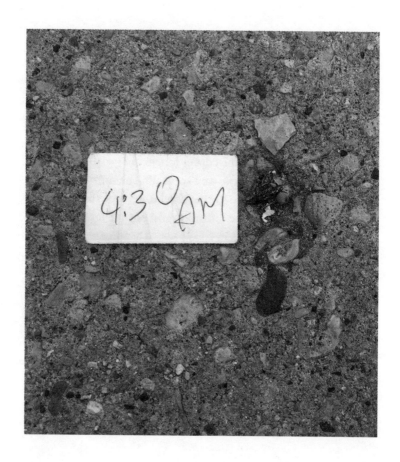

IT'S LATE

4:30 a.m. is as deep into night as you can go without spilling
out into the break of day. Any later, no matter the time of year,
and you're flirting with a new date, not the dregs of what's left
behind. I trust the dregs more than a flirt, though that is neither
there nor here. Better to look for the light, or bask in the dark?
Darkness is cold, no matter what the temperature, so absolute
darkness is absolute zero.

There is an elusive part of the darkest night, the same 4:30 a.m.,
and it's what we know of domestically ineluctable hell; inescap-
able, they say, no way out, darkness that lurks around the doors
and docks. Dark lipstick, dark sighs.

Who then is passing out this stray invitation to the edge of
night? Or who, I wonder mournfully, left a kind of breadcrumb
to say they just couldn't get out, glued as they are, subdued in
that moment of dark, dark, dark.

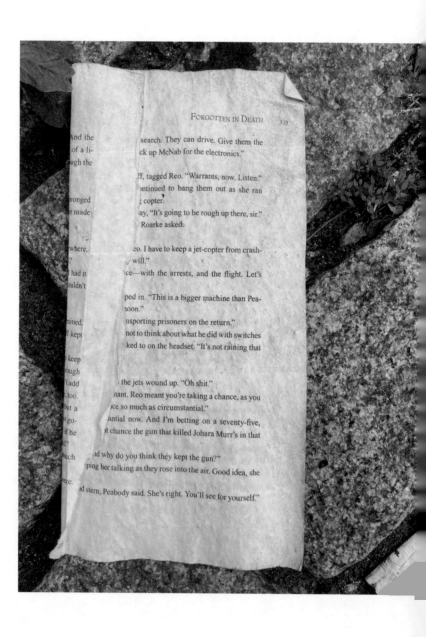

And the
of a li-
ugh the

search. They can drive. Give them the
ck up McNab for the electronics."

ff, tagged Reo. "Warrants, now. Listen."
ntinued to bang them out as she ran
; copter.

ronged
r made

ay, "It's going to be rough up there, sir."
Roarke asked.

where,

had it
ouldn't

eo. I have to keep a jet-copter from crash-
will."
ce—with the arrests, and the flight. Let's

ped in. "This is a bigger machine than Pea-
noon."

nined,
l kept

nsporting prisoners on the return."
not to think about what he did with switches
ked to on the headset. "It's not raining that

keep
rough
add
too.
ut a
l go-
if he

the jets wound up. "Oh shit."
nant, Reo meant you're taking a chance, as you
ce so much as circumstantial."
antial now. And I'm betting on a seventy-five,
t chance the gun that killed Johara Murr's in that

uch

d why do you think they kept the gun?"
ping her talking as they rose into the air. Good idea, she
eze.

d stern, Peabody said. She's right. You'll see for yourself."

FORGOTTEN IN DEATH

It's easy to forget the ecosphere of the lost page, when language without a speaker tells you that words are all that matter. I see this image as a park with different-sized trees, lanes to stroll in alongside the granite monoliths—a memorial, perhaps?—and the giant postmodern sculpture of a cigarette butt in the lower right. The canopy of the page gives shade where the perambulators can find some relief from the afternoon sun. Two leaves, one in the form of a gondola, the other a grand yellow squash, fill out the landscape of this strange space. Suddenly I am very small.

The bad noir prose compels me: what is the context of a page dispiriting in its fragmented ordinariness. Is there anything more melancholy than printed ephemera, language lying on the street, homeless, needing a transfusion or, barring that, a very long rest in a home for aged prose, where, before it is forgotten in death, it can sit outside in the world along the adjacent lanes and consider the life of the page that might have lived in another place and time, under other circumstances.

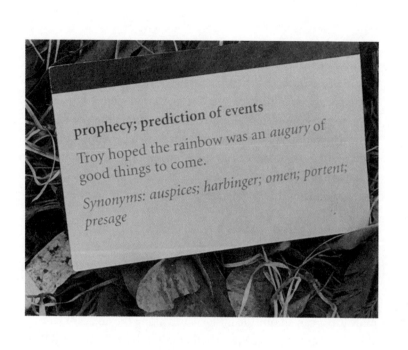

prophecy; prediction of events

Troy hoped the rainbow was an *augury* of good things to come.

Synonyms: auspices; harbinger; omen; portent; presage

TROY'S PROPHECY

Troy hoped the rainbow was a prophecy, an auspice that his friends had portended, presage-wise. The dope of the omen was that his little skiff could finally make it past obstacles. His old inamorata Helen said she'd give it a whirl, the sailing, if it could make it past the proverbial rocks, which is to say, water-wise. But what's in an augury, you're probably thinking. An auger here, an auger there . . . pretty soon you're in too deep. You go around presaging, and the next thing you know you're caught betwixt and between, not knowing the line between what's in the net and how to bail out the boat. But Troy loved a prophecy, a harbinger, a portent. He thought that part of life's job was in harbinging. And his old inamorata Helen had promised to sing a song about the past being nothing more than an aeolian harp, music-wise. So, as so often happens when people of good will are yearning for good things, they set sail, morning-wise. Who could have predicted what happened next? Not I, for one, and as for prophecies, Troy might be dashed, and Helen's secret hopes sunk, but I never in a million years would have thought I'd get that price for the skiff.

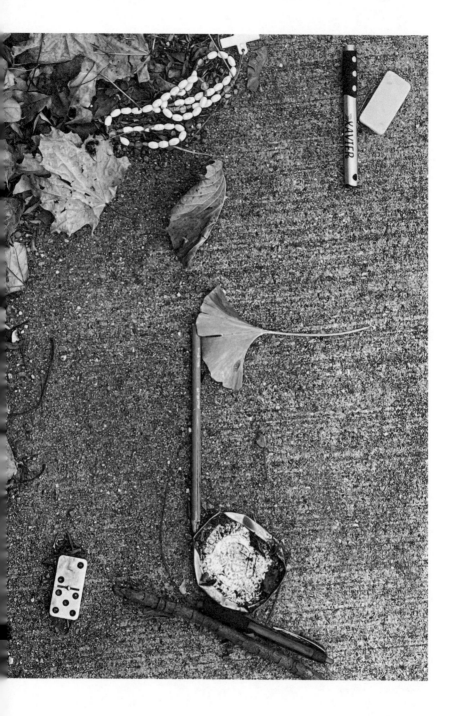

DOWN BY THE LAKE

Dominoes is an ancient game, originated in China, refined in Italy. Down by the lake, where the humidity is high, they combine it with the rosary, originated in Italy, never successfully imposed on China. Low tide, high tide, a Xavier pen can put marks where marks need to be: on ivory tiles or poems written on granite that the lake water will take days to wash away. How about a funny little moustache when that woman falls asleep? The sky today was alternately sorrowful and mysterious. Looking down at my hands, my fingers seemed like a luminous five. That sleeping woman, will she play a game with me called Marian Dominoes? I have a wet pen for keeping score.

Jane Burton
Coral Reef

A young sea horse eats as
many as 3,500 shrimp a day
and grows more than twice
it's size in less than a
month. clown fish have never

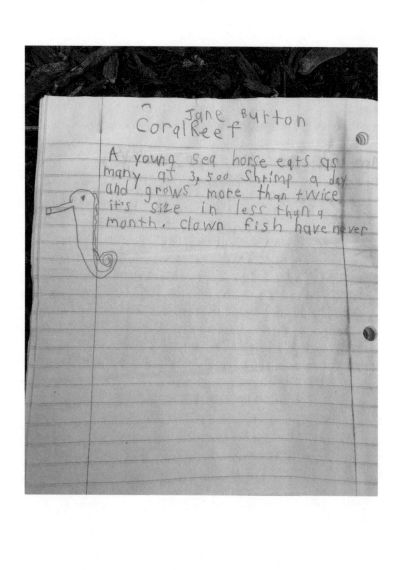

JANE BURTON

Me a young sea horse whose Daddy owns an undersea gallery.
I eat lots of little shrimps, which sometimes I feel bad about
because there are so many and maybe somewhere deeper down
their daddies have tiny little galleries in the dark bottoms. I do
gulpy gulpy like Mama says because I have to grow big, and
Daddy shows me a picture of Jane Burton, which I don't know
what that means of the big creatures that live on land.

This is a picture of Jane Burton's. The big creature can swim
maybe but I don't know if they have eyes or eat the shrimpys.

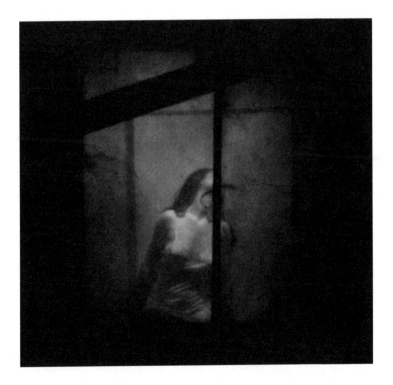

Sometimes it makes me sad, don't know why, like she don't know how to swim maybe, but I think she does. This Jane Burton I don't know how Daddyfish knows her cause she's a lander, but pictures are everywhere in the not sea and the float world, and here where almost everything is, down. My daddy owns a place where you can swim and look and all the other finnies grab a peek.

Clown fish have never. Clown fish don't like to look. But everything else likes to look. Sharkies and crabbers, lobstas and gourameries. When I grow biggers I will swim away and find that strange thing in the picture. But gillymere says I must got to go far to find her, that's what I hear, to find something strange you got to swim outside the sound.

WHY DO SOME OBJECTS
FAVOR US WITH THEIR LOSS?

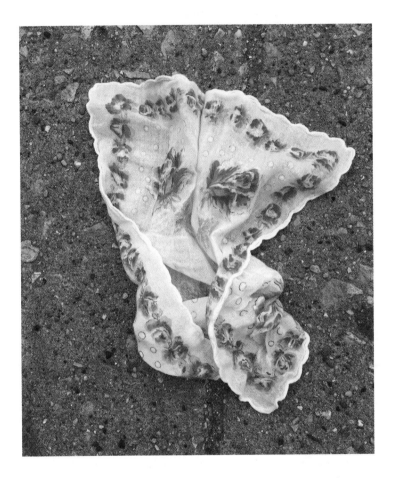

Why do some objects favor us with their loss; why do we favor some lost objects over others? The same, of course, could be asked about people, the special niche that occupies abandonment and betrayal, the attention that is required in mistreatment: attention has been paid!

Not usually encountered as lost or discarded (crucially different) on the streets of many cities are lipstick, fine-tooth combs, prosthetic limbs, and cat toys. The more common discards I've encountered are hairpins, clips and twists, torn and wet shirts (wet from what, one wonders?), and from a baby carriage whatever an infant can pitch into perambulated limbo. Occasional bras and hair extensions, ubiquitous gloves (usually one), and masks on almost every street everywhere. Are masks technically clothes? Do they represent a new and exciting opportunity to litter?

I have found complete outfits in corners near apartment buildings, hats off and sullenly useless, and then this delicate floral kerchief. Or is it a doily, fallen from some doily cart? This is a lost object with flowers blooming through the urban banality of sidewalks, the canvas that only breaks its geometric rigidity through brokenness. A cracked sidewalk is at least a sidewalk with character, the character of time.

The conundrum of the shoe or shoes. Note: Stifle all puns involving "bootless." Shoes, I've found, we usually notice immediately upon losing, but still they appear everywhere. I like to imagine an invisible person is standing in them. The solitary lost shoe is a mystery that even Sherlock Holmes might not solve.

I've always had an affinity for earrings, my gold standard for lost objects: always solitary, and one must want to see them to find them, so often small and missing one stone. Usually costume jewelry. Shouldn't all jewelry be costume jewelry?

When I was a boy I found a wedding ring in a pay telephone coin return. I believe the manager told me to keep it, defiling its value, but I'm not married to this story.

The world is the department of the lost and found. We have all always worked there.

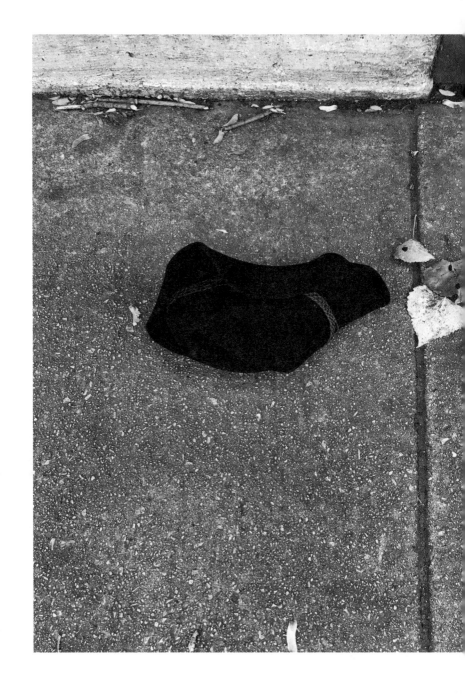

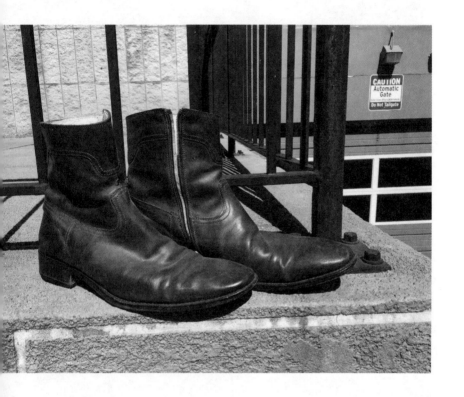

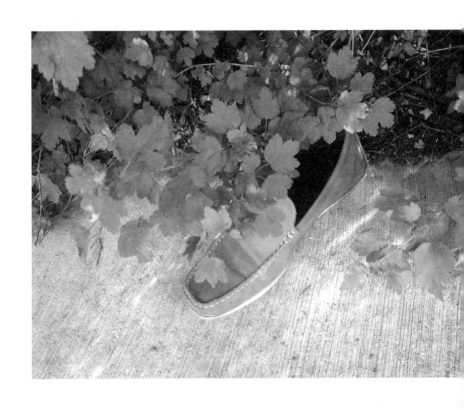

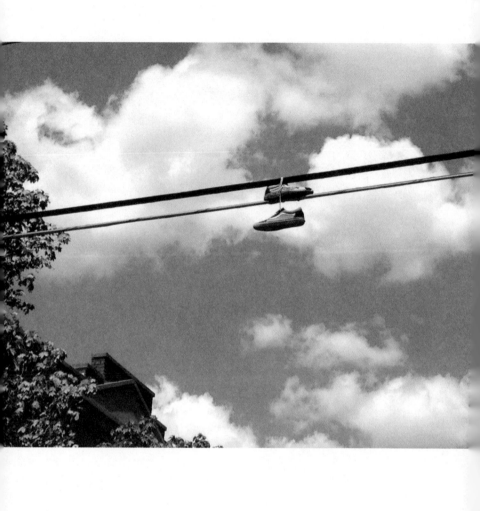

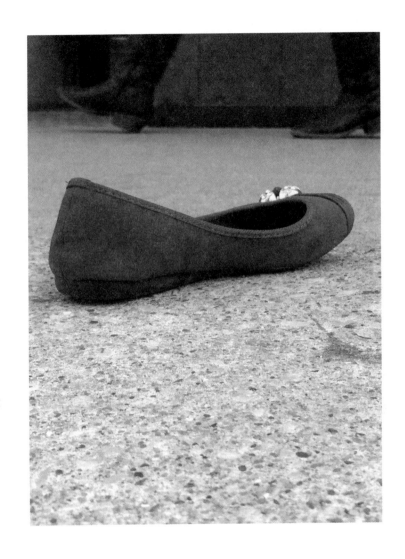

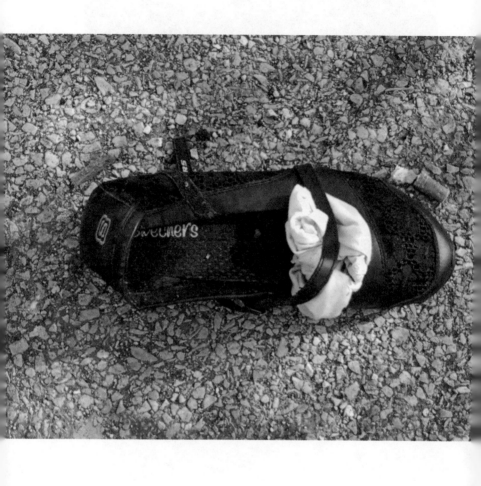

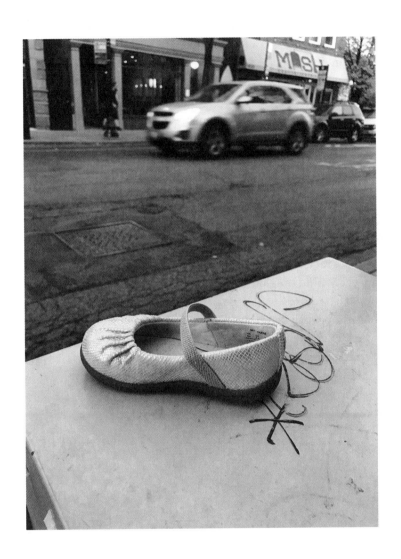

Sneakers hang from wires, but how do they get there?

I've seen loafers, cowboy boots, Uggs, stilettos, baby shoes, pumps, and loafers scattered around the street, a diversity of shoes in diverse places: gutters and stoops, parks and fences. I have a fantasy of a dream of walking through the city in a foggy night encountering only limping, singly shod shoe salesmen. The all have a mournful countenance born only of those who search forever for their missing other shoe, the Platonic ideal. Will the other shoe drop, I wonder? Was it ever witnessed?

At some point all the missing clothes, shoes included, disappear from the street. I assume its ordinary street cleaning, unless a more fetishized minion of collectors appear before dawn to scour the thoroughfares for unredeemed garments. Whether they are re-sold or re-soled, displayed in secret museums that appear behind trapdoors and under manholes, or treasured as oblique treasures by their obscure hosts, I couldn't say. But I hope some early morning they find me walking and show me where to go to find these huddled masses of the discarded, once homeless, now prized.

JE SUIS V——, NAPOLEON

Add to Calendar

SILVER AIRWAYS Flight Number 3M 127 Saturday, 29 April
CONFIRMED

Departure: FLL FT LAUDERDALE, FL
 1:20PM
 TERMINAL 1

Arrival: GGT GEORGE TOWN BS, BAHAMAS
 2:57PM

Please verify flight times prior to departure

Class: Economy Duration: 1hour(s) and 37minute(s)
Aircraft: SAAB 340 TURBOPROP Distance (in Miles): 328

Mr Napoleon
Seat(s): 10A / Confirmed

Add to Calendar

View Trip in TripCase
Print Itinerary

Passenger name(s) and confirmation number(s):
Mr Napoleon 4492101148327

Je suis V——, Napoleon. Even in France, to have the name of Napoleon—no easy thing. Right? As a kid, all the other kids were like, *Hey Napoleon, how's Wellington doing? Been to Corsica lately?* In winter, they'd say, *Why gloves, Napoleon, just put your hands inside your jacket.* As you say, it got a little old. C'est devenu un peu vieux. I still think names are important, and even though mine was surdeterminé, c'est la vie; it was mine until I had no name. When you die you lose your name. You can only say, *I used to be so-and-so.*

I always like the turboprop—old movies, you know? Maybe Casablanca or something with Jean Gabin and Danielle Darrieux. Give the propeller a good hard turn. And a good hard turn is what a lot of lives have, if you're lucky to take off in the right direction. Me, not so much, mauvais sort, sort fatalite. Ma faute: comme Bonaparte, a little bad planning goes a long way. Here I must ask of you, change can happen anytime, oui?

That's what I tell myself. Je me parler I just need to land standing up on my feet. Maybe you know, in the Bahamas, I make my score, and I can change my name to Jean Gabin, fly back to Bordeaux, open a little wine shop on an ancient side street . . . the petit rue.

JEWISH MUSEUM

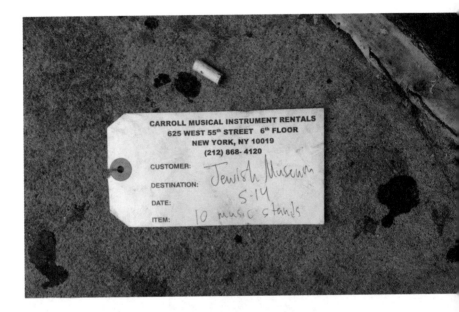

What, you think it's easy getting to the Jewish Museum? Darling! The detours! Sharp right at Copland, hard left past Mahler, down the alley toward Milhaud. . . . Darling, they won't lose your violin. It's all arranged, the musical minion. You listen, you play. Glass of schnapps.

Dad had a Heifetz record, and Mom used to say, if only. . . . What are you going to do? Cry me a river about all the things that haven't happened. Bernstein use to say memory can be serial or harmonic.

Where's your case, darling? It should have been tagged. Things around here are supposed to arrive on time?

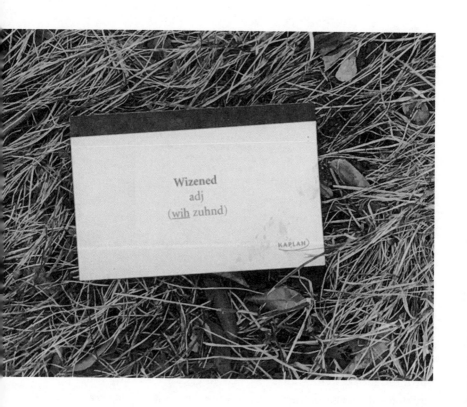

WIZE GUISE

To become wise; wise up, to become a wise guy, wise apple, wise acre: the "demi-hectare" of "sagesse" in French. Throughout Romance languages different measurements: smart foot, learned quarter mile, uppity yardage person appears in the Doomsday book. For wisdoming synonyms, in English: smarting, uplearning, soul-a-larged, and rare, wizlibecoming. The first use of "wizened" is said to be an erasure in *Paradise Lost*, "wizened duvil" later corrected to "Adam."

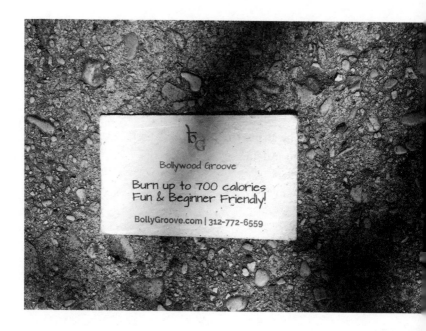

LIGHT MAN

You've heard of Fat City, but Fat Cinema? Right? Come now, our groove is two thousand films a day, you don't know? but that's way too many calories! If you like to watch, and who doesn't like to watch, we give you several alternatives: delicious masala cinema with a mixture of sweet-and-salty plots, a bit of classic comfort. We have evening dacoit for those in a hurry to drop the excess weight—say a wedding coming up, or are you in the throes of self-disgust? Ok, right, it happens! Hey, show you a photo of Priyanka Chopra— you'll lose ten pounds on the spot! Right? Like I'm not friendly? It's a groove. Just don't tell me you're a Satyajit Ray, man. Oh, brother. That's just dead weight. Barely Bolly, and let me tell you, you want to get a groove, keep it light man. Light man!

July 6, 2014

Breaking the seal on this new
notebook on the day I met with
Corrinne. This was a gift to me from
her, and I would do well to
remember all of the gifts she has
given me in the last three years.
I let myself go and loved someone
again, and now that it has come to an
end it would be so easy to spiral out,
to fall apart. To lock away myself and
my heart.
It is time I began to remind myself
of the beauty in this life, and of the
happiness it gives me. I draw strength
from this. And the optimism of people
who find the world always endlessly
fascinating is charming, attractive,
and deeply nourishing.
Take on what you were given by
this great love.
This will be a journal of return.
Of happiness. Of the things that
pull us together and keep us there.
You worry too much. Let yourself
remember what it is that makes you whole.
There is love and there is loss here.
Remember the love first.

LOVE AND LOSS

This stained message breaks my heart and begs a few questions. Why does it touch it me so much? Obvious to me: it's so ingenuous and hopeful, and mournful, the patterns repeated, hopeful, mournful, hopeful . . . "I would do well to remember," "I let myself go," "It is time to remind myself of the beauty in this life. . . ."

Why is it torn from its home, the journal? "This will be a journal of return," but July 6 is not on the train headed home. The page, asunder, cast out . . . but were there even other pages? If a few is more than two, then can one be more than one? Time . . . what of time? Remember the love first, then time will follow.

July 6, still the hangover from Independence Day when so many try to pick themselves up from a disastrous or overwrought picnic. A blanket on the grass, you must know, can lead to disaster. I found it years later, almost at my front door, a small tear in the center, the torn out of-ness apparent by the top slant correcting to the edge of the page starting at approximately the stain. It is a page that looks like it could use a shave and some new clothes.

Corrinne, the muse, always a complicated figure. You broke his heart, he who is unnamed. Was the gift of the notebook a consolation at the end? Did she offer it during a melancholy postmortem? I'm fascinated with postmortems of love, finding them interesting and repulsive. "Take this," she might have said. "You're going to need it."

Who is our young swain, and where are you now, Werther, our muse of loss? Forget Corrinne, I want to tell him, I think of you constantly.

spiritual understanding is changeless.
As this consummation draws nearer, he who has shaped his course in accordance with divine Science will endure to the end. As material knowledge diminishes and spiritual understanding increases, real objects will be apprehended mentally instead of materially.

450:19-7

The Christian Scientist has enlisted to lessen evil, disease, and death; and he will overcome
them by understanding their nothingness and the allness of God, or good. Sickness to him is no less a temptation than is sin, and he heals them both by understanding God's power over them. The Christian Scientist knows that they are errors of belief, which Truth can and will destroy.
Who, that has felt the perilous beliefs in life, substance, and intelligence separated from God, can say that there is no error of belief? Knowing the claim of animal magnetism that all evil combines in the belief of life, substance, and intelligence in matter, electricity,
animal nature, and organic life, who will deny that these are the errors which Truth must and will annihilate? Christian Scientists must live under the constant pressure of the apostolic command to come out from the material world and be separate. They must renounce aggression, oppression and the pride of power. Christianity, with the crown of Love upon her brow, must be their queen of life.

THRALL

I used to believe that animal magnetism meant all of our animal friends had magnets lodged in crucial but unseen parts of their bodies that drew us to them, made us want to be close to them. Zoos were pulling us through their gates like confused sleep-walkers; thinking we were going to see a hypnotic, circus-like dream, we never bothered waking up. I could never keep the zoo and the circus straight.

I learned that animal magnetism implied a form of natural sexual spirits, an aggressive humor that could hardly be resisted, and that therefore we weren't really children of the Enlighten-ment but craven and biologically determined, in utter thrall to the body. The mind-body question became the body question. *Thrall* . . . trails down from the Old Norse noun of serfdom to our sense of irresistible spiritual, emotional, or sexual enslave-ment. *I was in thrall* we say, as though we had entered a paradise of volition, an epiphany of surrender. No wonder this poor Christian Scientist tossed his sheet onto the decaying leaves. He didn't want to search for the truth. He wanted *thrall*.

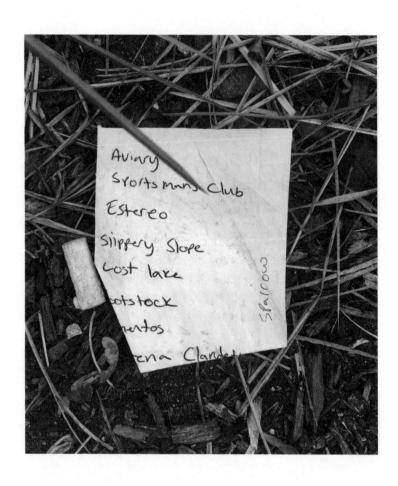

LOVE'S LOST LAKE

If I belonged to a sportsman's club, numero uno would be an aviary on their lost lake. Think of it, sweetheart, Xaviar Cugat in estereo, I could row you around the lost islands . . . and then you and I on love's slippery slope. What kind of bird you want, love? A sparrow? An egret? I'll make a note of it.

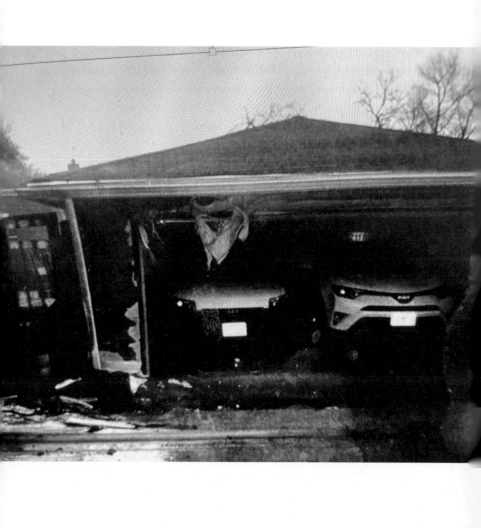

THUS THE PHOTOGRAPH

Was this a moment of disaster or pride? Has the storm passed, leaving everything a little battered, but more or less OK, as we are, year after year. Some things hanging, but the structure in, as we say, one piece. The ground is wet but not flooded, so let's all go grab a beer and laugh and say we dodged another one.

Or: did a shadowy figure slip into the darkness on the left having snapped. Something perhaps they didn't want to see, a visual phenomenon too uncertain, unsettling? So they left it for me. Thus, the photograph in my pocket in the night.

The cars are normalizing, white and white, ready to merge into the avenues of morning travel—we're all tired and anonymous. Without the scary black hole into which I'm now convinced something unspeakable had just disappeared, we almost have a sad midwestern version of the album cover of Jackson Browne's *Late for the Sky*. If the night is an empire, the photographer is a slave.

In any case, in desolation, of desolation, this photograph needed to be discarded, gifted.

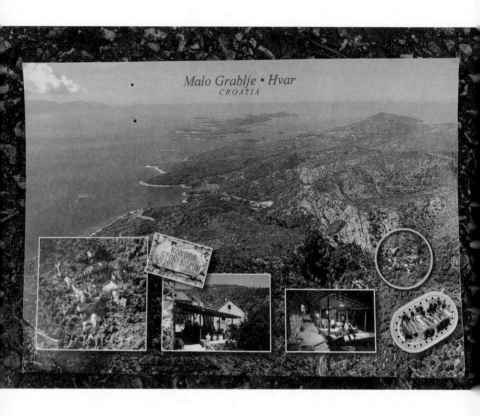

Malo Grablje • Hvar
CROATIA

MALO GRABLJE

Our town, Malo Grab, as we call it, is full of Tudors—all Tudors, in fact. The legend is that a son of Henry VIII came here to gaze at the Adriatic and never left. Every one of us is a descendant, the Croatian English. Every day, in homage, through times prosperous and meager, we sip on a tea with crumpets, little ginger snapping turtles. That is our English side. Fifty years ago we had to leave our village, in masses as we say, to move to the coast, one mile to the Dalmatian coast, from which we had been separated all through the years. The years, we feel the heaviness, as you say, but love this bit of Hvar, this island that some Croats call "No place but the end of your desire." It is difficult to translate. Some say, "heaven." Others, "dead end with a very lovely view and good food."

We were separate from the coast for a mile because of the pirates all those years, and we could have moved to what we now call Milna sooner, but one stupid group of Tudors kept saying they liked their garden, and we all agreed we'd move to the village together, all of us, or not at all.

You have to use imagination on an island like this. Inland Croatian Tudors that we are, the wind of the Bay of Kotor on our face. Come see us, please, this is my request. I give you this sake for keeping, this depicted card of our lot. We love company, you see. And our daughters, our sons could use a little shaking up. A Plantagenet or Stuart. A recipe without fish or chips.

AMSTERDAM 26-12-74

00140

[handwritten text in Greek, largely illegible cursive]

I AM WRITING THIS IN CHICAGO

I found this card in Athens in 2013. It was night, and I was a bit drunk. The card, written in Greek, pictures Brussels, was sent from Amsterdam, written in 1974. I am writing this in Chicago, in 2020. Being lost doesn't mean you don't get around.

This what the card says in Greek and English (translated by Joanna Eletfheriou):

Αγγελική γειά σου,

Από το Άμστερνταμ σου στέλνω τις ευχές και τους χαιρετισμούς μου για τις μέρες τούτες. Χθες γυρίσαμε από τις Βρυξέλλες που μας άρεσαν ιδιαίτερα. Μεθαύριο θα πάμε στην Κολωνία (Γερμανία) για δυο μέρες και μετά στο δικό μας χωρίο. Ο καιρός είναι ουδέτερος. Πότε πότε βρέχει λιγάκι αλλά όχι τόσο ώστε να χαλαστεί εντελώς η μέρα. Ο Μπάμπης κι εγώ σου στέλνουμε τις καλύτερες ευχές μας για ένα ευτυχισμένο χρόνο.

Χαιρετισμούς στον Γιώργο και θέλω τη διεύθυνσή του
Πολλή φίλιον Κώστας

Angelica (Angeliki) hello,

From Amsterdam I send my good wishes and greetings for the holidays. Yesterday we returned from Brussels, which we particularly liked. The day after tomorrow we will go to Cologne (Germany) for two days and then to our own village. The weather is neutral. From time to time it rains a little, but not so much as to ruin the day. Babis and I send you our best wishes for a joyful new year.

Give my greetings to George—I want his address.
Regards,
Kostas

The weather was neutral in Amsterdam in 1974, maybe neutral in Greece in 1941, weather like a father who went to the hills to hide or fight outside of Doxato. Also in 1941, neutral weather meaning no Jews behind the walls on Prinsengracht. In Brussels in 1974, Chantal Ackerman's mother sat at a desk writing her letters from home. The weather in New York was not, as usual,

neutral, but threatening a sullen commentary like a raised eye-brow. The World Trade Center had just been completed. In 2013 in Athens, just a spot of a rain, a spot, so the postcard was dirty, but dry. I am usually dry and dirty.

Angelica sends her regards to Kostas. A new year coming. A day not ruined, thanks God. Nevertheless, what is saved is never saved forever.

ON WEDNESDAY, MARCH 8TH, AT SIX O'CLOCK P.M. . . .

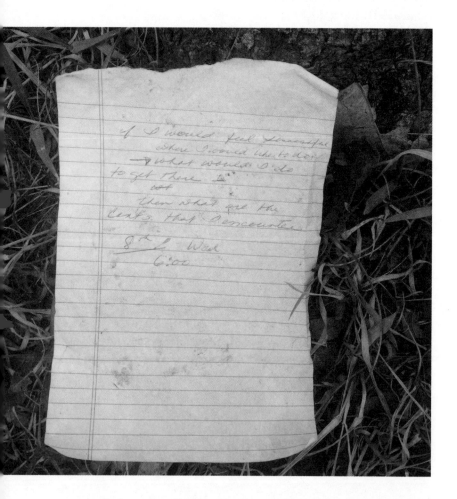

I took that sense I had worked so long for: my mother had long told me that feeling successful is a matter of where more than what—I took that understanding to the Cable Building at Wabash and Jackson, which is where I was supposed to be any-

way. I rode the elevator up to the 86th floor. *What are the cant's that I'll encounter?* I thought, as my father came to mind. The little voice in my head, which sounded a little like Edward R. Murrow, repeated this over and over again, I'm not sure why, but it seemed determined to find an answer, no matter how qualified. When I emerged I was elevated, and I thought, in an optimistic way, that moments of inner disquiet are long hallways full of dark transoms and stenciled doors. There was a strange sound of metal hitting concrete far away, but I wouldn't let anything shake my balance until I reached the door of destiny—it was almost six o'clock, and a Wednesday, no less—dust motes alight, as I started running toward my ravaging future where everyone, including me, would be timelessly fashionable.

a glass of wine imported from Crete. She made a lazy inspection of the farm—the accounts, the state of the orchards, the gooseboy and his geese, the buildings and outbuildings, and in the evening she came to a conclusion. She decided that Bianca no longer needed a nurse, and Primavera could be let go.

"Go where?" said the cook, grinning as toothily as her teeth would allow.

"Go. Retire. Haven't you some feeble spawn to take you in? They've foisted you off on us for far too long. Go back to them and require that they obey the Fourth Commandment, and honor you, whether you deserve it or no."

"There's no one," said Primavera.

"No one who will murmured Lucrezia. "Who could blame them?"

"I lost both . . . to Cesare's war," said Primavera pointedly. "The ill-fated attack . . . Forli wasn't good for our family line. They were stupid and foolish but they were my sons, and they're gone. My only grandson is a hunter, and seeing what consumption did to his father and uncle, he keeps out of the way of the soldiery. He lives by his wits, no place special, and I can't go root in a tree to find him. I haven't got the hips for it. I should mention that he takes an interest in displaying his handsome head on a stake on the wall of some castle Cesare wants to occupy, and therefore the better to his head, unlike others in his family."

"So he's out of reach," mused Lucrezia, in a pleasant threatening way.

Primavera was on her mettle. "As it happens, he's here today; when I saw that you'd arrived in the nighttime I sent for him, so he could provide us some meat for the table. He's here to protect me should I need it."

"You're not listening," said Lucrezia. "Go throw yourself on the mercies of the almshouse. Throw yourself off the precipice behind the apple orchard. I don't care. Just stuff your personal items in the cleft of your bosom and take yourself elsewhere."

MIRROR, MIRROR

When I walk down Broadway on my way to get a cup of cof-
fee, I usually
Go. Retire. Haven't you some feeble spawn to take you in?
feel the anxiety lift a bit, knowing I can read the *Times*, lose
myself in the obits,
*the accounts, the state of the orchards, the gooseboy and his
geese,*
the way I've done since I was eight, since I unfolded the big
paper with news of Adlai
Primavera was on her mettle. "As it happens he's here today . . ."
Stevenson, Nat King Cole, and Everett Dirkson. Anything that
isn't me is such a relief, since
*They've foisted you off on us for far too long. Go back to them
and require that they obey*
the simple obsequies of the day. Strange that the daily banali-
ties and funerary rites soothe
whether you deserve it or no. There's no one.
And that's OK, it's really the beauty of the early sun-drenched
languors of your dread that
*"You're not listening," said Lucrezia. "Go throw yourself on the
mercies of the almshouse."*
Almshouse. I love that word. It's so comforting in the dis-
tanced dread of its meaning. Is that
Go. Retire. Haven't you some feeble spawn to take you in?
why I read so much?

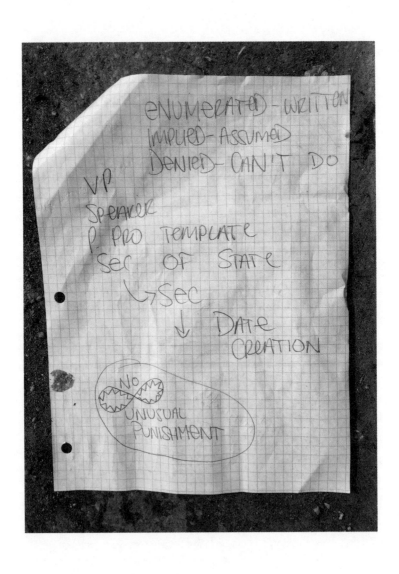

NEW WORLD ORDER

New World Orders begin on scraps of paper. For example, no pro tempore or pro counsel for this New World Order, baby; pro template is the New World Order. Teams of web designers decide proper sentencing, but it's all on the up-and-up: no punishment that doesn't fit the web box. If you're wondering what I mean by this, see Rosenberg, Ethel; Vanzetti, Bartolomeo. Not to mention Jesus and the like.

My Pro Template, decked out in pixilated robes, obsequious like Tom in Tom in Jerry after he's been smacked for being bad—oh, I've got my eye on him! Like I really want a sidekick, right?! You see, implied is as good as assumed when you've checked out all the angles. I watched an entire movie about Mussolini when Dad was in his crazy WWII phase and once listened to *Evita* straight through. I know from whence I speak, I date my creation at the thought of myself as something really special. I wrote it down, Date=me. Mom always said, if you write something down, that means it will really stick. Then the unusual punishment of dry meatloaf and eggs that were implied, rather than assumed. Now, back to the New World Order. . . .

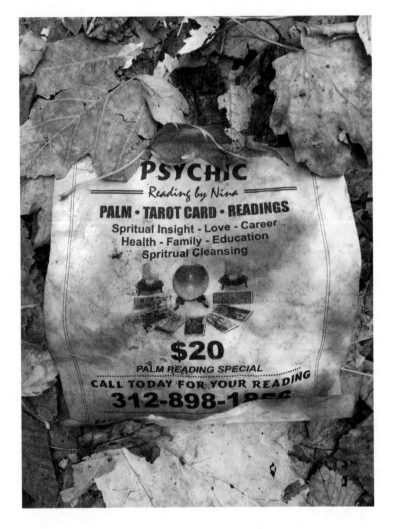

READING BY NINA

Nina, what do you see, now that all I have left of you are leaves among the leaves.

When I first walked in, were you seeing me leave. Did you see your own shawl cover your tears, or had they aged from previous readings? Nina, is revision a form of bliss to you, the future updated, possibility enshrined as . . . possible. *Oh, the poetry of determinism* you whispered in my ear.

When we first met, I remember: an undoing would require myths beyond my imagination, and you whispered, almost in my ear, *you're so ever reluctant and I think you like it.* It made me want to reluct.

Here's my spiritual insight: the rain against my window is warm, and you never finished that sentence about how to put your hand through a window when you really need to.

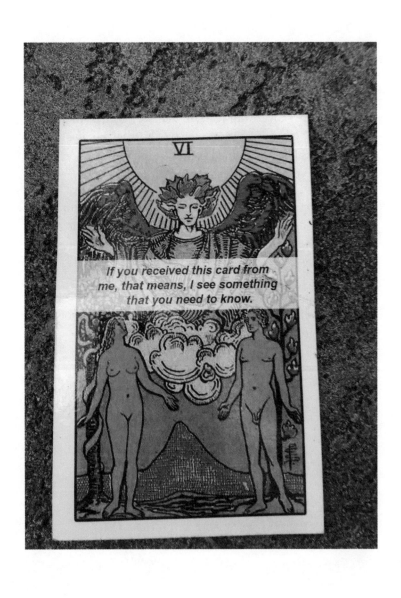

If you received this card from me, that means, I see something that you need to know.

READ, GODDESS

The old canard (not to be confused with a conundrum) from childhood: if we could see the future, would we want to, wouldn't it corrupt our decisions, haunt our acts of kindness, and temper our bets at the horse races. How many science fiction scenarios play with this conceit? Still we go to see the woman with the shawl, ask her how long our parents will live, if our lovers will stray, our lives will extend, if Jerry Van Dyke would replace Jesus eventually. I always wanted to ask if I would ever have a dream in which my mother were dead. So this note beckons, its proviso (How I love that word—sorry sir, you cannot cross the border, your proviso has expired!) is that we *need* to know; it reverses the trope of damaging foreknowledge (called, by some, the Edenic paradox), and tells us that we *must* know, that foreknowledge is necessary, as though that were a foregone conclusion.

I hasten to this woman—inevitably readers are women, since a man in a shawl is by definition uncouth—who promises, after such a good long run, to reverse original sin. She's the apple of my eye.

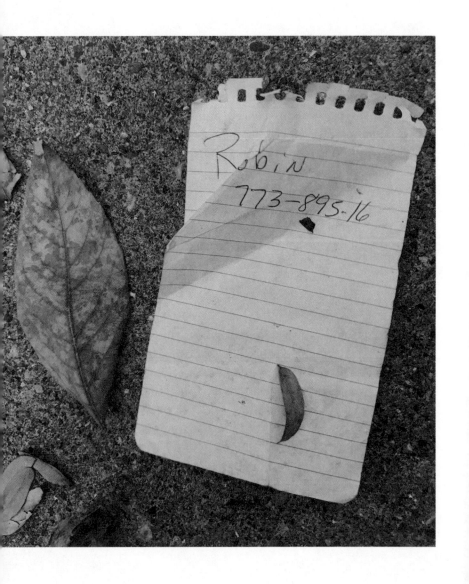

ROBIN?

It takes a measure of optimism to name a child "Robin," what with the Hoods, the Redbreasts, and the singing of "Red, red," bound to be a legacy. So as much as I was fascinated by the long brown hair, the come hither look, the subtly muscular biceps, it was Robin's parents I wanted to meet. How did they justify and what had become of them. Did they still have the Robinesque optimism of young parents thinking a child will bind them to the world and each other? Had the bright glimmer in the eyes, that quality of thinking the next landscape will be magical, "just as we imagined," as you grasp the other's hand in the car as storm clouds gather over Erie, Pennsylvania, vanished, or just aged into a slighted quizzical squint?

Robin, harbinger of spring, you genial outlaw, they set you off into the best of all possible worlds, bound to better than the so-so of all possible worlds they grew up in. Robin bought my friend a beer, though my eyes were on Robin the whole night, not the beer. My friend asked for a telephone number, and, in true cad style tossed it to the ground with a laugh the following day. My desire is to call and say, oh, yes, we met, and might I speak to your parents? Are they together, alive, nearby. Are they who I think they are?

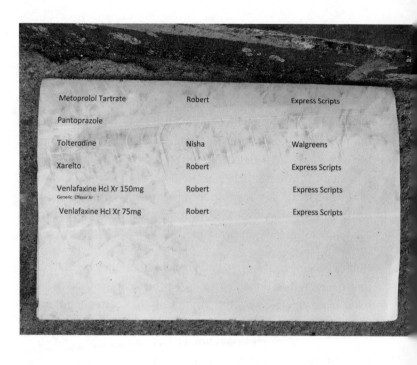

Metoprolol Tartrate	Robert	Express Scripts
Pantoprazole		
Tolterodine	Nisha	Walgreens
Xarelto	Robert	Express Scripts
Venlafaxine Hcl Xr 150mg Generic Effexor Xr	Robert	Express Scripts
Venlafaxine Hcl Xr 75mg	Robert	Express Scripts

SCRIPTING

Stopped at the border, I was forced to explain:

The Metoprolol Tartrate is for an intolerance to seafood condiments.

Pantoprazole is for lingering effects of mimeism. At the right dose, I rarely make air drawings of windows or doors.

Tolterodine I take once, or maybe twice, daily, and admittedly it's an esoteric drug, as a preemptive for vacillation, especially in the mornings, no, afternoons, and after excessive consumption of either peanut butter or Zoroastrianism.

Xarelto. I don't take this, but I made them put it on the list. I like saying it. I must say it! Xarelto!

Venlafaxine in its two doses are completely different drugs. One induces giddy flights of laughter. Like this: Ha-ha! The other repeated readings of Wittgenstein. My pharmacist, who I call "Daddy" for obvious reasons, tells me it's all in the balance. After all, I met my deductible—a bit high if you care to know—on December 18, a clear night with a rainbow of stars shooting through the sky everywhere.

SEQUENCE

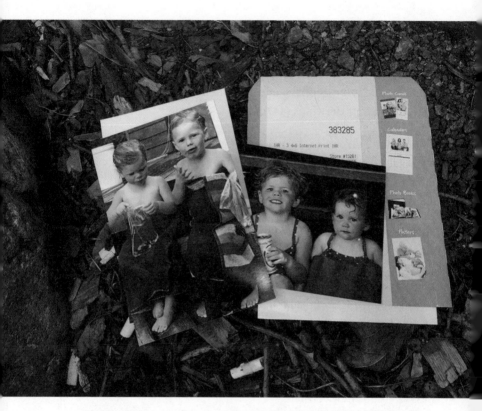

Seemingly a complete set, adorable kids, probably siblings. But out of envelope, face up, recently receipted . . . it seems impossible that they were dropped. One can read intention into how some things lie on the street. Let's say they lay near the streetlight on the corner because the owner, let's say a man, though not necessarily a man—let's say I'm projecting my gender, projecting loss, tossing off assumptions of pain, of imagined narratives—couldn't bear looking at them because of separation.

Cute kids, and in three of the four faces shown they're looking straight ahead, looking at, let's imagine, the person who took the photos and then threw them away.

Once, when I lived in Ohio, married with a young son, I walked down our long driveway to check the mail. I lived in a big house. The mailbox was across an exurban road. Before my vision could organize what the bunch of papers scattered across the road were—almost everything is initially detritus—I went to pick them up. Someone had driven by and tossed a full pack of photos in a photo envelope out the window of a car, and the photos were strewn across the road, about a thirty-yard spread no doubt because of the speed of the car. It was a windless day, Watson. I picked up all the photos and brought them inside, and in my sometimes OCD-ish way, tried to arrange them—there were about twenty-five photographs.

Getting the order right seemed very important to me. The photographs showed an outdoor birthday for a child, the usual Americana accoutrements: tables of food, balloons, groups of people posing with mostly awkward smiles, the birthday boy made to pose over and over with different subgroups. But in one photograph, just to the side the children arranged at front, stood a man, somewhat red-faced, receding hairline, glaring almost murderously at the camera.

I've remembered his look through the years, since he seemed ready to do violence, to burst the balloons, set fire to the house, run into the dark woods behind the house screaming something like, "All for naught!" I could hear my wife moving upstairs, my son playing downstairs.

I don't know if I still have these photographs. I haven't looked at them for many years. At some point it became too painful to imagine what might have gone wrong.

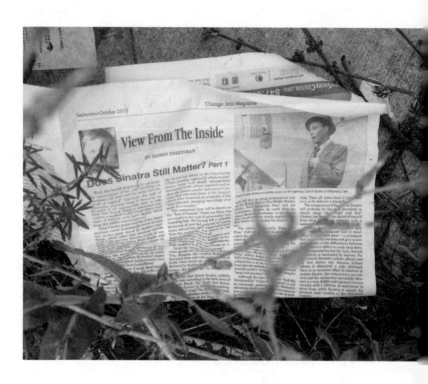

View From The Inside

BY RANDY FREEDMAN

Does Sinatra Still Matter? Part 1

SINATRA MATTERS

Perhaps I should have been working, balancing the books, or building a chair. Maybe I should have been calling what's their name, and saying, "I'll do it," or "I'm sorry." Call me irresponsible. I had the world on a string, though the world seemed like it had no strings attached, and there at my feet, like a view from the inside, was the question that stopped the world in its tracks: "Does Sinatra Still Matter?" Oh, just look at the photo: it swings, and what it sings is summerwind, even though it might as well have been spring. I had been lately basking in the wee small hours of the morning, that place for only the lonely, but . . . look at him with his hand on his heart, a tilt of his hat. There was the answer I had been waiting for: sincerity. Have I ever committed to a song, I said to myself, putting the clip in the inside pocket of my blazer? Zing, went the strings of my heart! Does anything matter except Sinatra? Is there a world without Sinatra? It would be full of stupid somethings.

SEPHORA + **PANTONE**

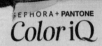

Color iQ

Sephora's Color iQ takes the guesswork out of choosing
shades that are perfect for your skintone. This exclusive beauty
service scans the surface of your skin and assigns it a Color iQ
number, which reveals precise lip, foundation, and
concealer matches that are unique to you.

Bring this card in to any Sephora location
for your free Perfect Lip Mini Makeover.

4 00018 02461 4

WHAT'S MY COLOR IQ?

Black, black, black is the color of my true love's skin. Perhaps not really black, which as a color is a cultural conceit. Color changes with the light, but skin is something everyone should get lost in, if they know what's what. What's my color IQ—is it deficient, damaged, am I selectively color-blind, the spectrum deranged by desire? Am I a blue genius, red Mensa, or just a pair of green eyes in the crowd? Is love the concealer or the revealer of surfaces? I gave my love a black, black rose. A white light on the dermis, that planetary surface we rain our tears on—does it let us see beyond what's too hot to touch?

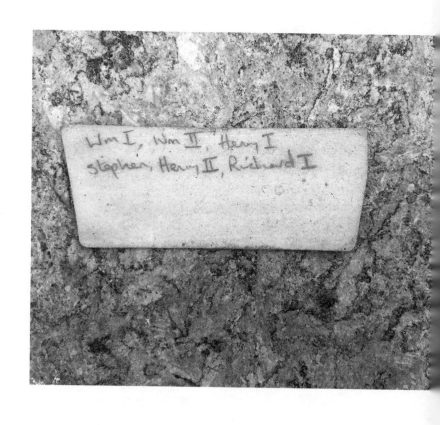

SUCCESSION

Succession is a mournful concept, acrobats balanced on each other's shoulders crying, teeter-tottering as they grin grotesquely and step blindly on children's heads and the shit of melancholy farm animals. Swirling around them as they try to keep their balance are arrows from Anjou, tears of Aquitaine, a peasant girl in the next tent covered in gore. In the middle is Rufus, who never made this list, thinking not of the Angevin empire, but a nice bowl of stewed prunes.

11-13-08

I temperature could Be rain, snow
Hail sleet and storms, Rain is made from
the chils and warm wethe and Cold wether

TEMPERATURE COULD BE RAIN

Western winds are made of down rains and wended wilted
Christ. Cold, wet, and chilled, he slips down the spouts of houses
on the outskirts, abandoned buildings of the arrondissements,
paint peeling, sleet blue could be a color. Now, I say, finish your
homework and climb into bed. They say tomorrow the winds
will be worse.

	GM	Ecolab
Milk	– Ask	– Ask for
OJ	Karena to	extension
Meat	speak to Shanghai	on Monday ~~sponsor~~
Veggie (less spinach)	people	~~pay~~ (1 mo)
Noodles	– Ask them	– Chances
Cereal	compensation	for starting elsewhere
Condensed milk	SH vs. Detroit,	first
Curry	whether rotation back to US is	
Coconut milk	guaranteed, smooth transition?	
	– L1?	
	– Let Amour know abt ECL offer	

THE TIGERS, BABY

Baby, the Tigers were so bad this year. Speak to Shanghai. I'll
make some curry and we can let Amar know about the EU offer.
Baby, I know you love the Tigers. You and your WARS and the
games with twelve people in the stands and bad beer. But we
could start again in Shanghai. We could be the Ecolab of love.
I can make curry in Shanghai like there's no tomorrow. We'll
let Amar know about the EU offer. Baby the Tigers were so bad
this year. And you know I love a guaranteed, smooth transition.
Karena, speak to Shanghai, let Shanghai speak to you. Ecolab is
our pompatus, baby, like there's no tomorrow.

When my alarm rang, I quickly applied another
layer and tried to keep myself busy. Finally it came,
the knock at the door. "That's for me!" I yelled.
"Anabelle, I expect you home by 11 p.m.," Mr. Talbot
asked firmly.
"Yes sir." I smiled then opened the door to find
Ravi in a black and white suite and a bow tie
"Hi Ravi."
"Hi Anabelle." He smiled. "Shall we?"
"Ok, but my dad told me I need to be back by 11."
I stated.
"Fine with me. Ravis reassured me "You look
wonderful."
"Thanks."
"So tonight, I'm taking you to dinner and then some
drinks. I plan on getting to know you more... outside of
school." Ravi replied, leading me to his car.
"Sounds like fun, thank you." We rode in his car
in silence.
"What changed your mind?" Ravi asked
"I had such a busy schedule in the afternoons I
could never say yes." I replied
"Had? I'm assuming you're no longer as busy then?"
Ravi asked
"That's right." I smiled "I'm happy I could finally
say yes to you."
"Here we are." Ravi pulled into a parking spot
and got the car door for me.
"Thank you, Ravi." I smiled

TELLING A STORY

Reading comprehension questions:

1. What is the relationship between Annabelle and Z?
2. Why does Ravi want to know Annabelle more, and what does Z seem to think about it?
3. Which of the main characters wears a bow tie, and in what situations?
4. Does Mr. Talbot ever open the closet to reveal the terrible things he's been hiding from his daughter?
5. Why did Annabelle try to throw her story away, especially since it was just getting juicy?
6. Did Ravi throw the story away after Annabelle gave it to him?
7. What is the significance of the bow tie?
8. How well does Annabelle know Z?
9. What kind of car did Ravi drive and why was he texting instead of looking at the road? Why didn't Annabelle tell him to stop?
10. Why did Annabelle choose a young man like Ravi instead of the Bonsaro, the insurance salesman upstairs, who was slightly overweight but wore straight ties and had an annuity. Was it because he couldn't drive?
11. How significant is the absence of the mother of the story? Does this seem to be connected to the role of Z?
12. If you could summarize the theme of this story, would it be,
 a. Impetuous youth always ends in near tragedy until rescued by ironically tinged hopefulness?
 b. Bow ties are ruinous for couples beginning to explore the possibilities of a life together through driving?
 c. Fun is frequently the basis for long-lasting love?
 d. If you change your mind, you should tell someone so they can see your mind has clearly changed?

Locations of Found Texts

The Worry Anchor	Croton Dam, New York, almost fall 2023
Ghost List	Grand Central Station, August 14, 2023
(Boy) (Girl)	Chicago, 2020
A Knife on a Fault Line	Brooklyn, 2014
Air Quote	Chicago, 2017
Apocryphal	Chicago, 2016
Basement	Chicago, 2018
Big Dog	Manhattan, 2015
But Seriously	Washington DC, 2016
Carly, Sorry	Chicago, 2019
Chicago Hotel	Chicago, 2015
Closing Time	Chicago, 2017
Distaff	Chicago, 2016
Face Down	Carmel, California, 2016
A Supposed Examination of Entanglements	San Francisco, 2015
Two Times Six	Chicago, 2013
Action Petition	Rolling Meadows, Illinois, 2020
Fireball	Chicago, 2016
Forty-Eight Bucks	Brooklyn, 2015
Have a Light, Janine?	Chicago, 2018
Hermeneutics	Manhattan, 2016

Interval	Westfield, New Jersey, 2016
It's Late	Chicago, 2014
Forgotten in Death	East 60s, Manhattan, I don't remember when
Troy's Prophecy	Chicago, 2016
Down by the Lake	Chicago, 2020
Jane Burton	Chicago, 2015
Why Do Some Objects Favor Us with Their Loss?	Chicago, Manhattan, Chicago, London, Chicago, Los Angeles, Chicago
Je Suis V——, Napoleon	Delray Beach, Florida, 2015
Jewish Museum	Manhattan, 2013
Wize Guise	Chicago, 2016
Light Man	Chicago, 2017
Love and Loss	Manhattan, 2014
Thrall	Houston, 2016
Love's Lost Lake	Chicago, 2015
Thus the Photograph	Chicago, 2017
Malo Grablje	Chicago, 2016
I Am Writing This in Chicago	Athens, Greece, 2014
On Wednesday March 8th, at Six o'clock p.m. . . .	Chicago, 2018
Mirror, Mirror	Chicago, 2015
New World Order	Newark, 2015
Reading By Nina	Chicago, 2019
Read, Goddess	Dublin, Ireland, 2019
Robin?	Chicago, 2019
Scripting	Iowa City, 2014

Sequence Chicago, 2020

Sinatra Matters Chicago, 2015

What's My Color IQ? Chicago, 2017

Succession London, 2019

Temperature Could Be Rain Chicago, 2014

The Tigers, Baby Chicago, 2018

Telling a Story Manhattan, 2015

Acknowledgments

I am grateful to the following stalwarts for continued suste-
nance: Cathleen Calbert, Nina Coil, Piper Daniels, Heather
Frise, Bruce Fuller, Delmore Lazar, Martin McGovern, Alyce
Miller, Eliza Nichols, Roy Weinberg, Lois Zamora, Steven Zuck-
erman. Special thanks to my wife, Elizabeth Davis.

Many thanks, too, to Courtney Ochsner, my editor at
Nebraska, for herding this book through the gates.

To all those who littered with emotional intent or merely fed
my hunger accidentally through what they casually discarded or
lost—thanks; I always have your back.